Brilliant Tattoo Designs For Stress Relief

Color Creative Works

Copyright 2015

All Rights reserved. No part of this book may be reproduced or used in any way or form or by any means whether electronic or mechanical, this means that you cannot record or photocopy any material ideas or tips that are provided in this book.

SPEEDY PUBLISHING

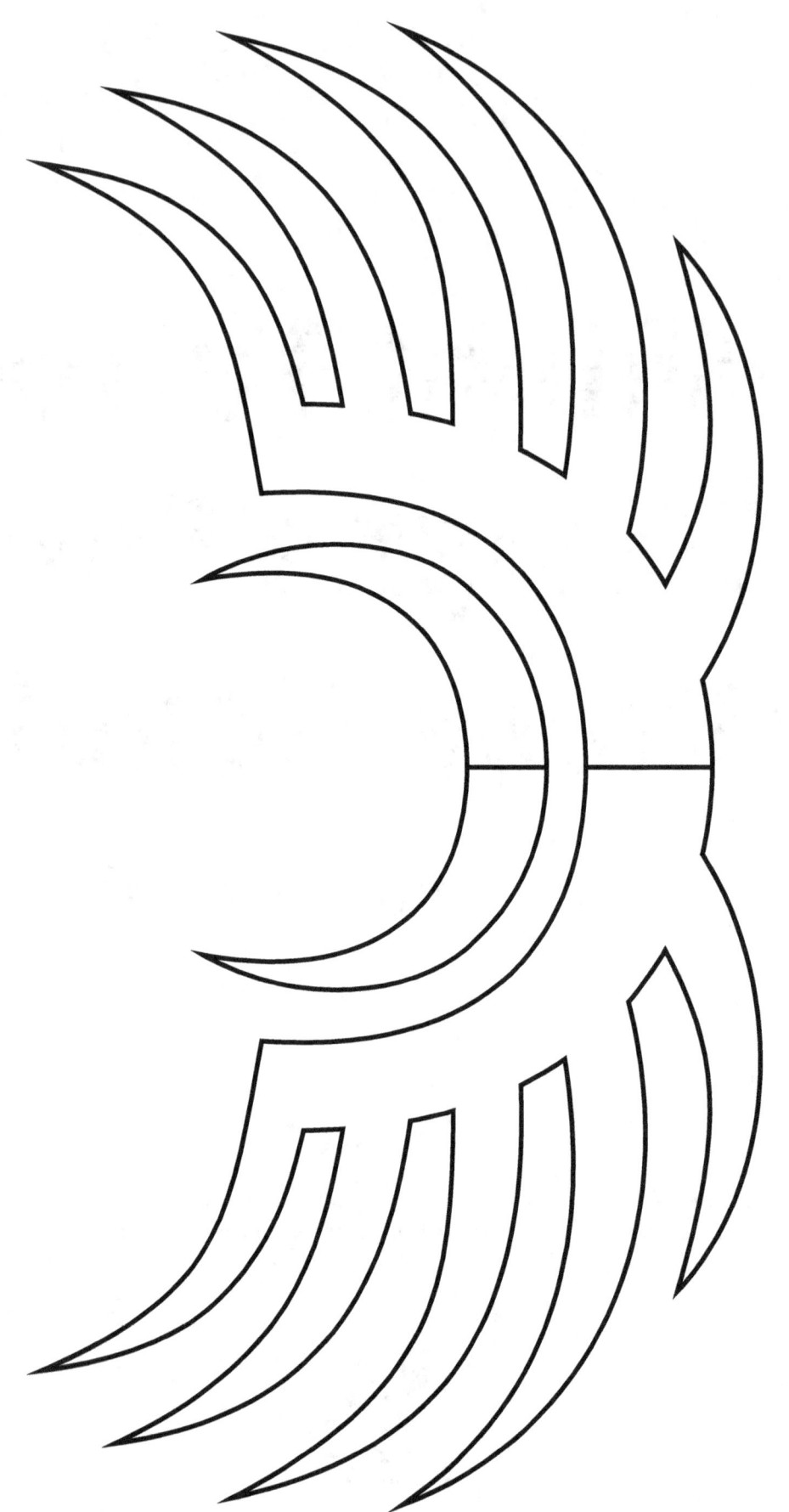

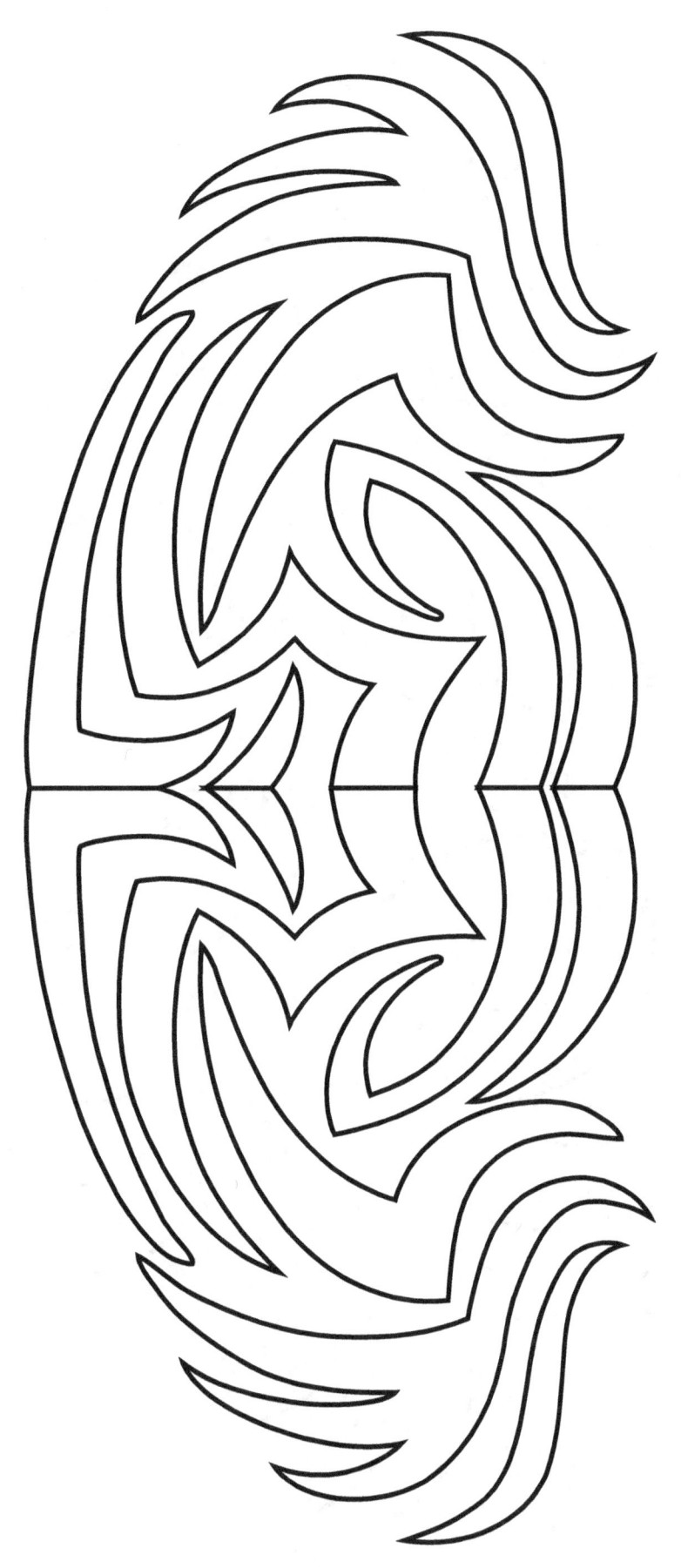

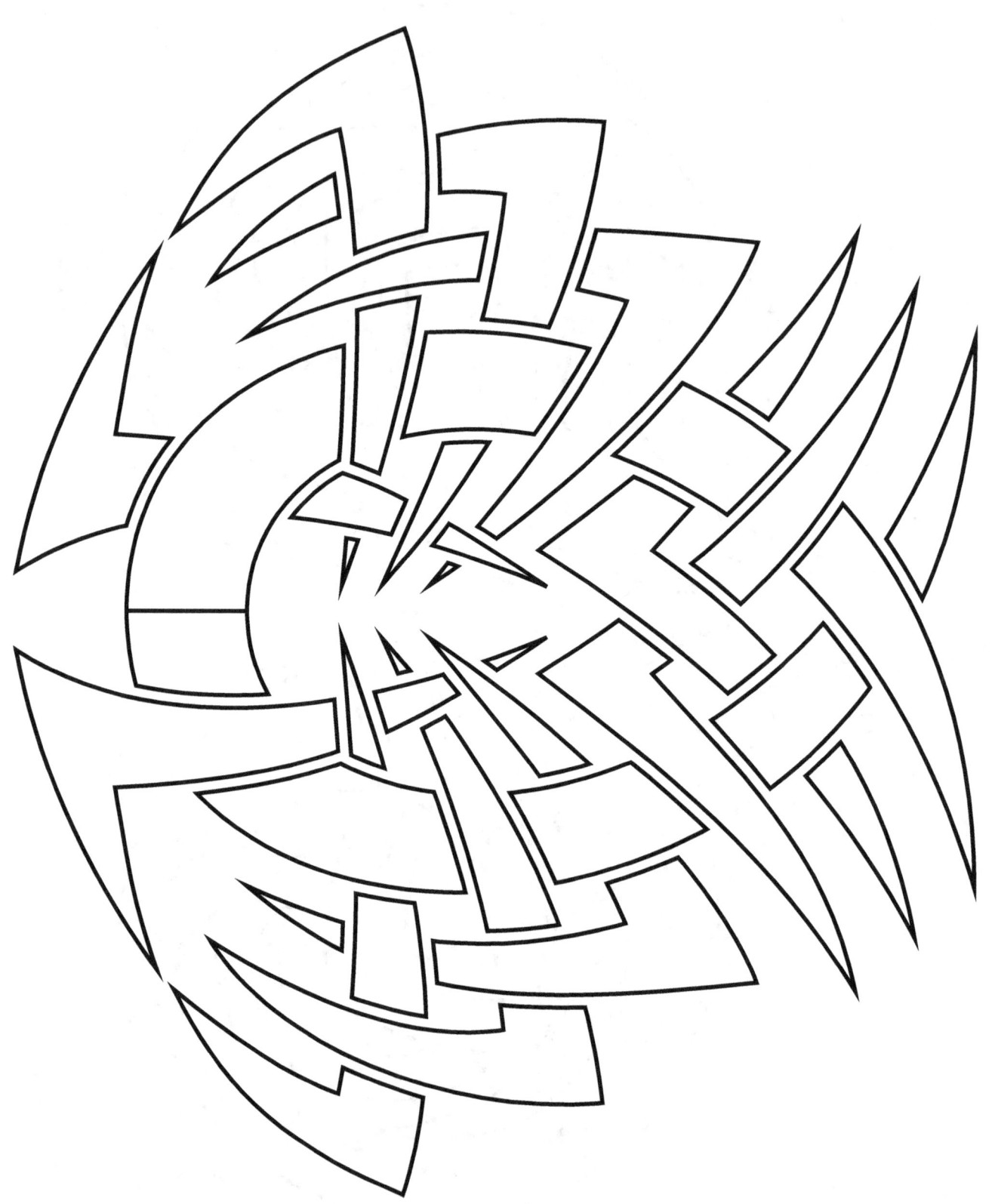

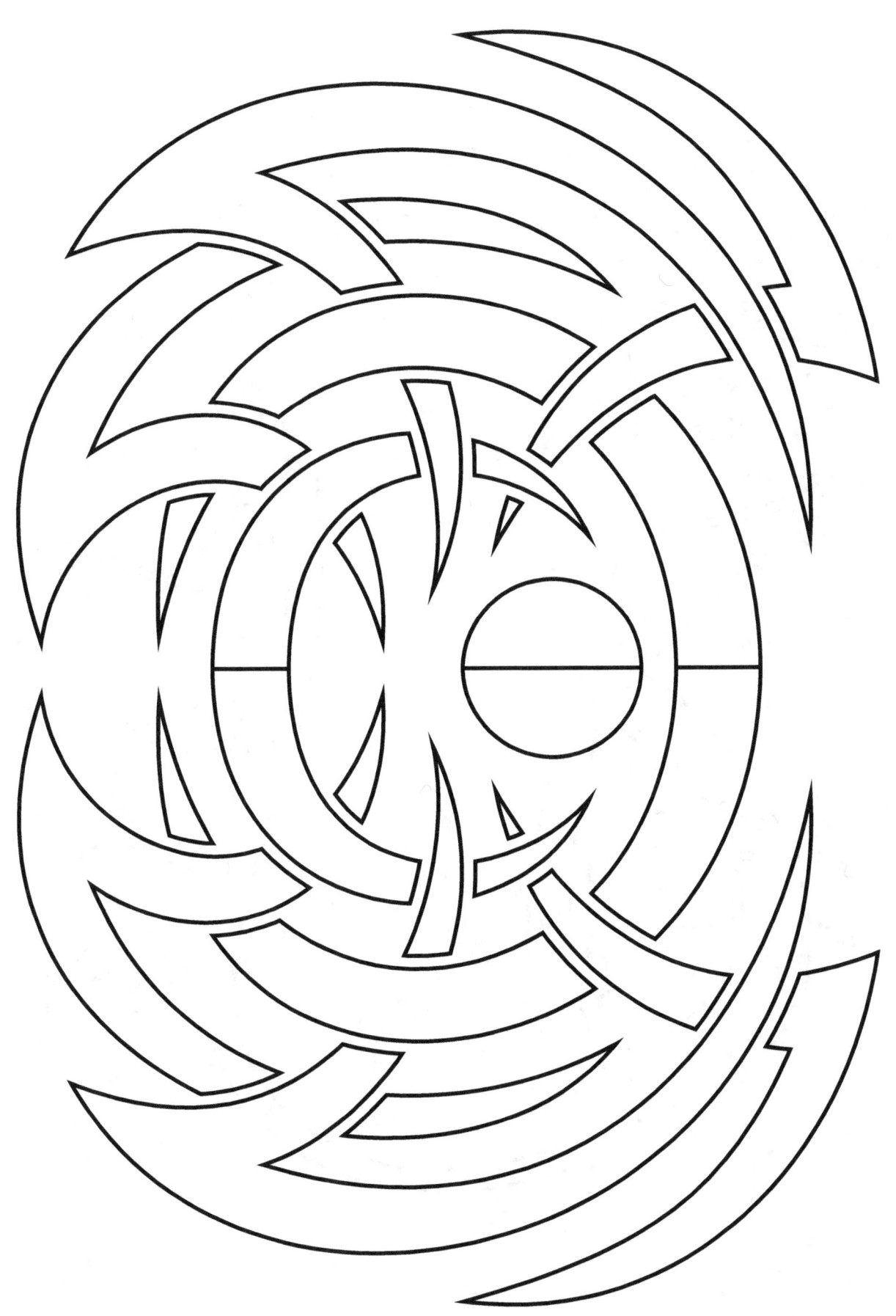

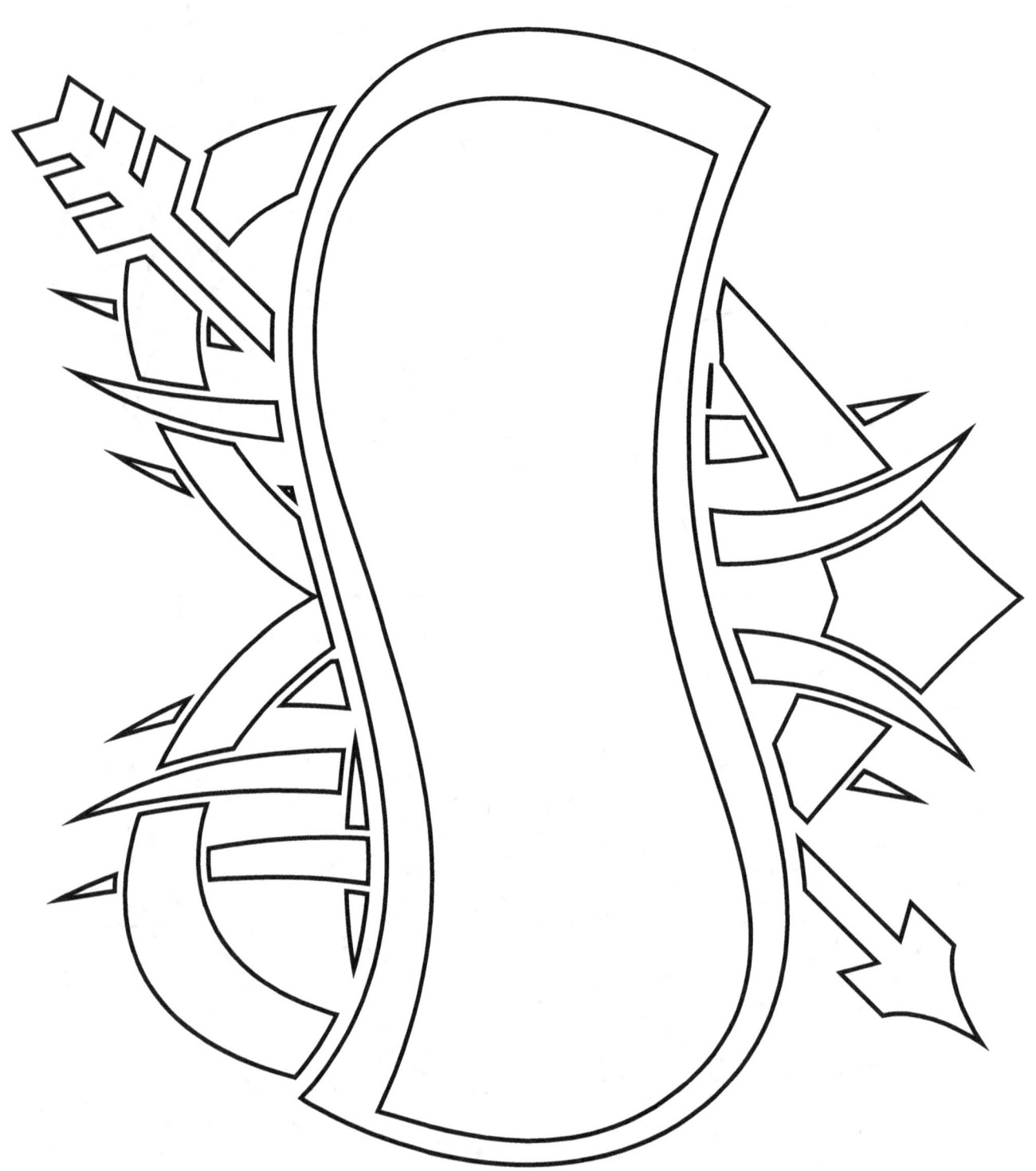

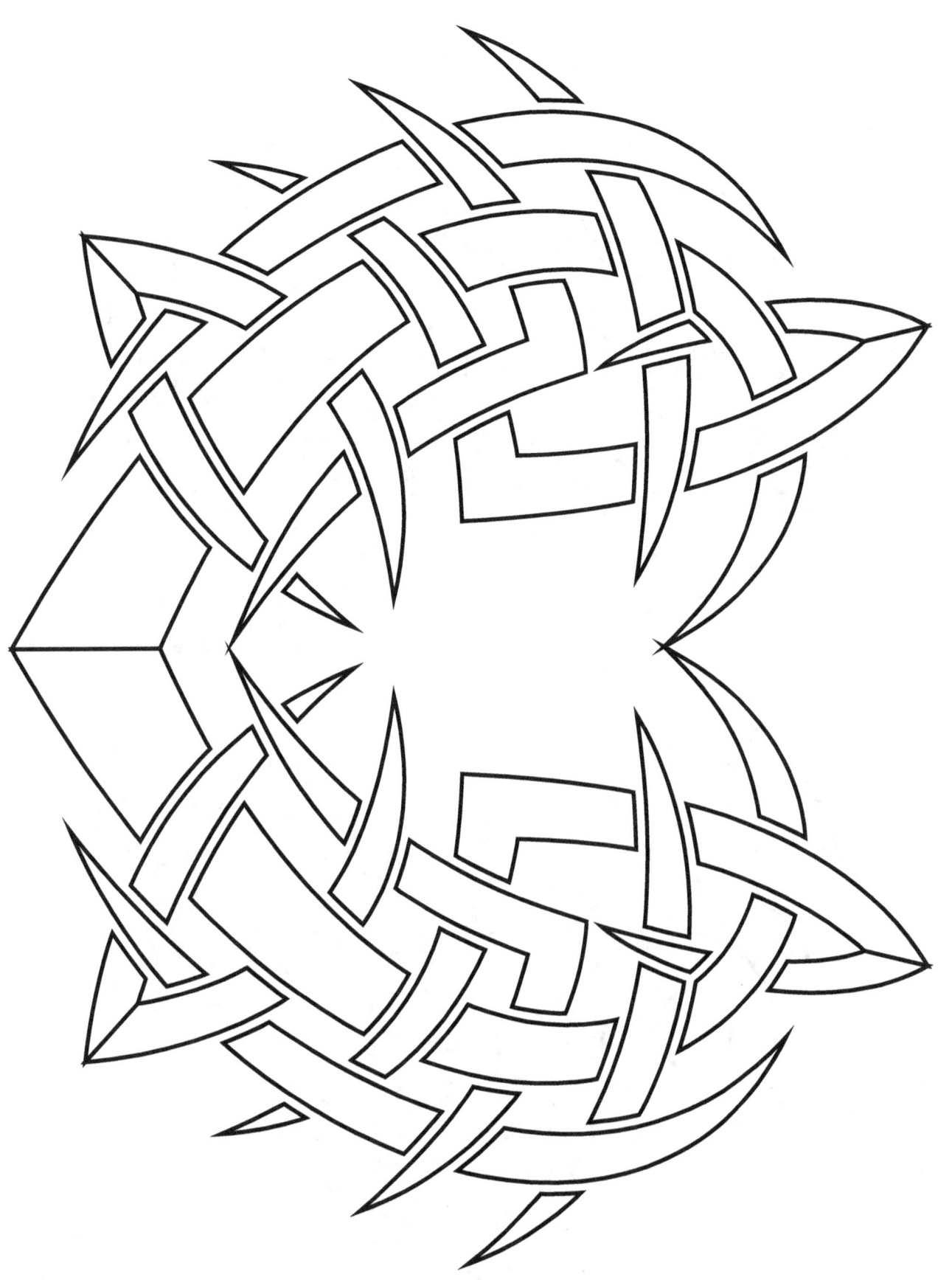

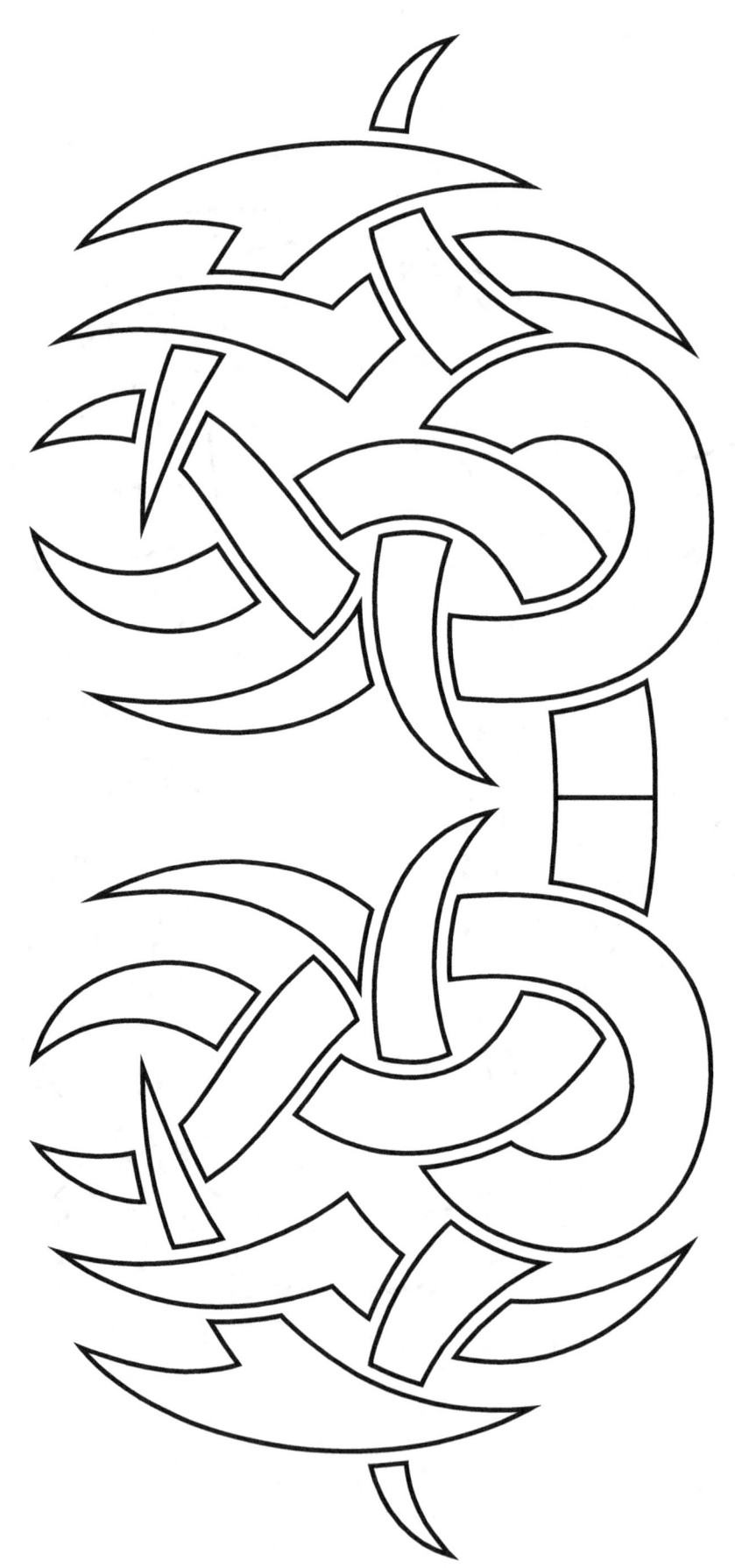

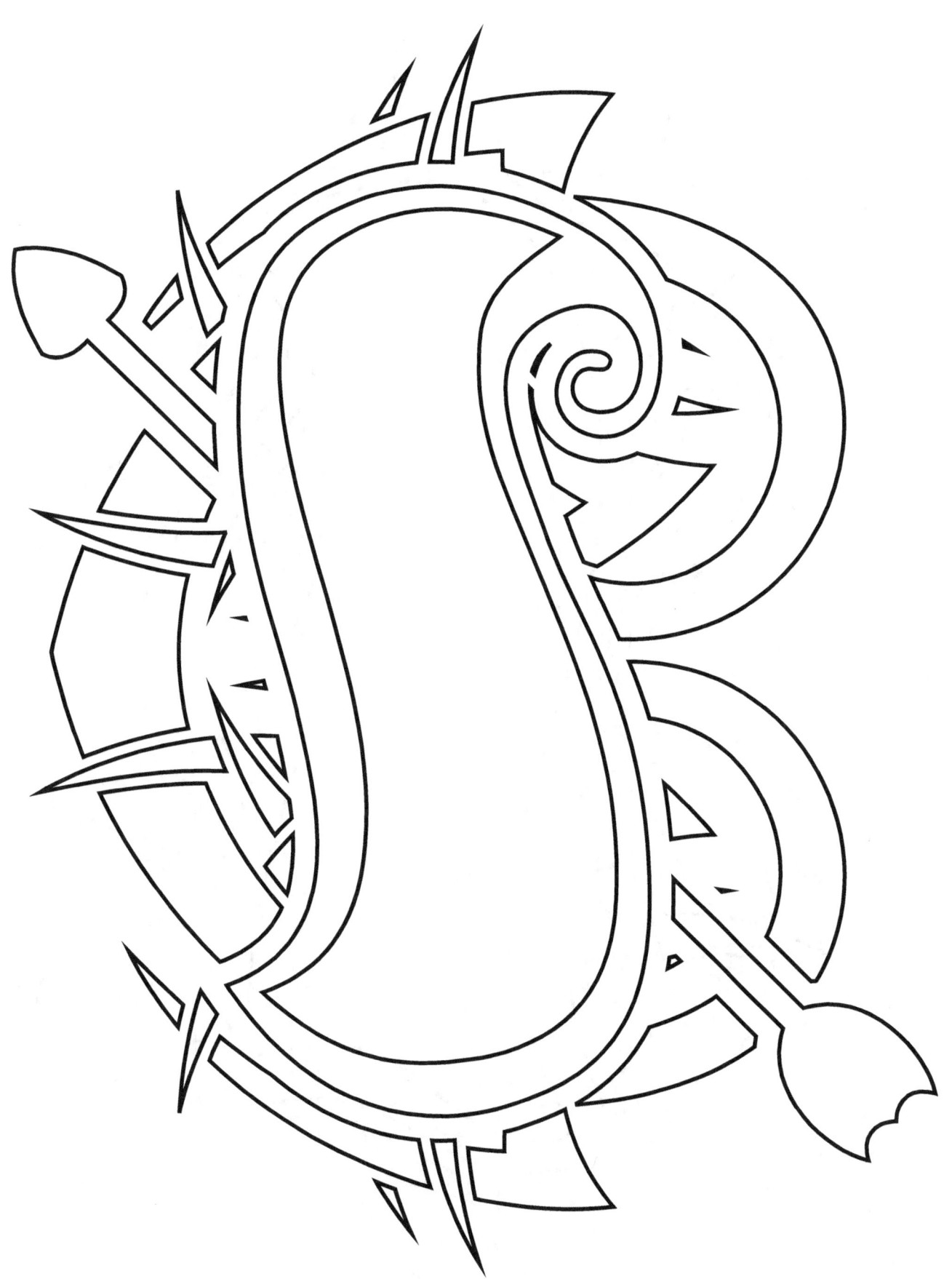

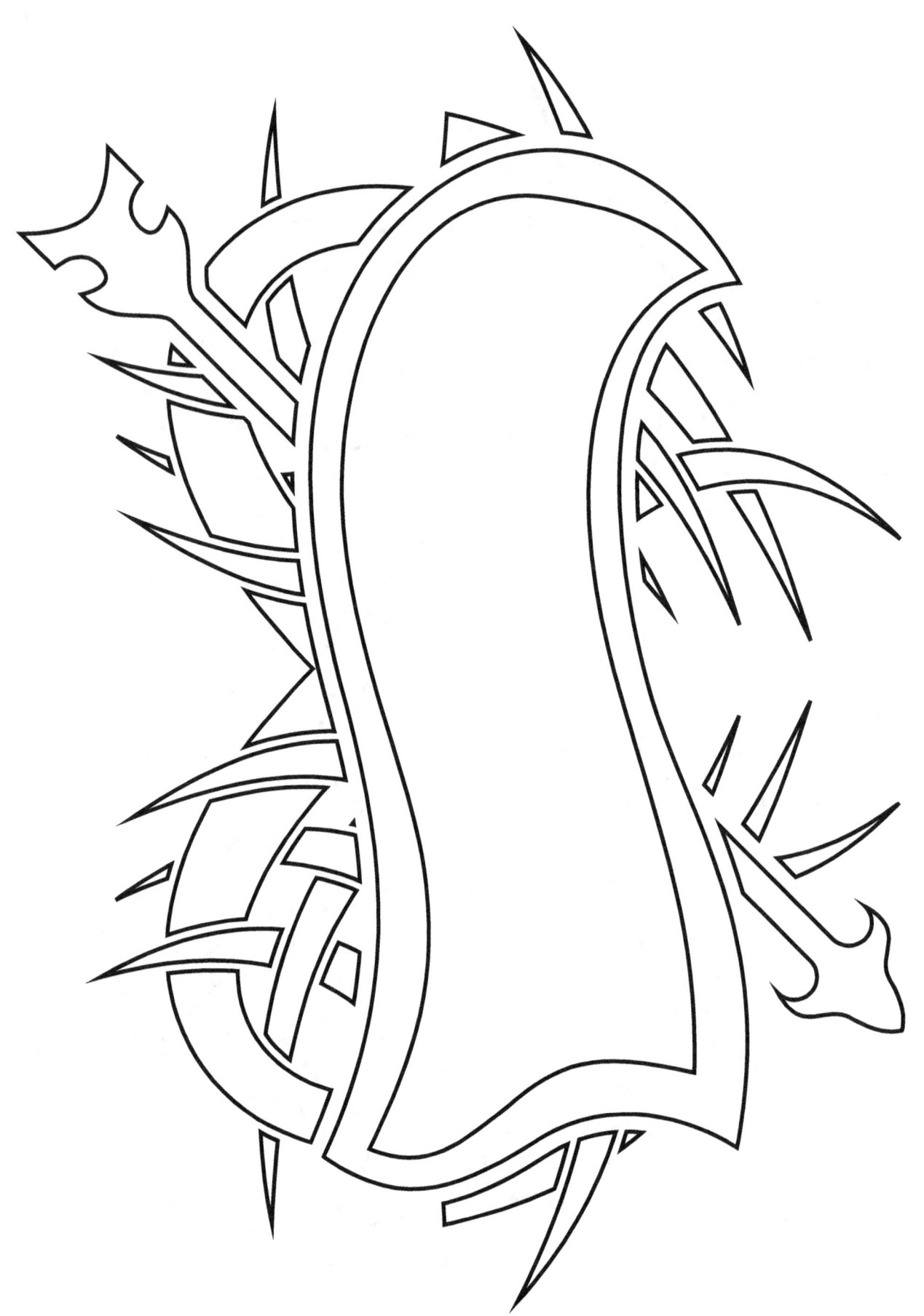

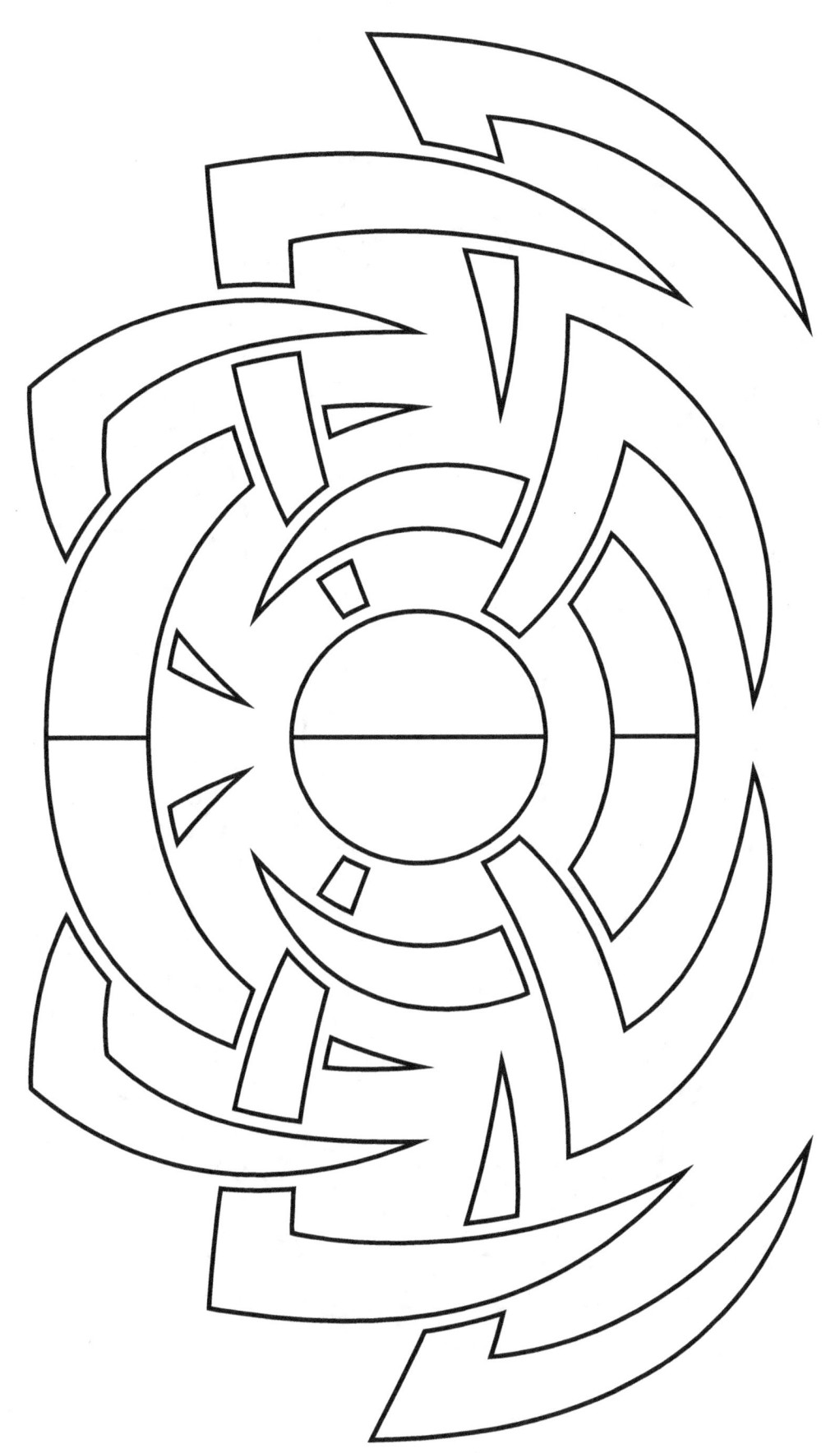

www.ingramcontent.com/pod-product-compliance
Lightning Source LLC
Chambersburg PA
CBHW081438220526
45466CB00008B/2440